FIFTY MASTERPIECES
OF ANCIENT NEAR EASTERN ART

G49 XLT$1.00

G49 XLT$1.00

649

I1027907

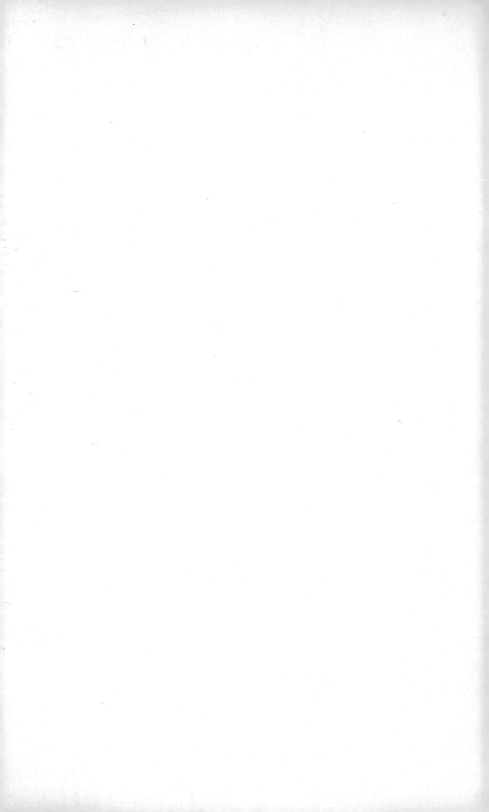

G49 XLT$1.00

Fifty Masterpieces of Ancient Near Eastern Art

in the Department of Western Asiatic Antiquities The British Museum

by

R. D. BARNETT & D. J. WISEMAN

Published by the Trustees of the British Museum

LONDON 1969

(LUMA)
N
5345
.B7
1969

© 1969 *The Trustees of the British Museum*

7141 1069 8

First published 1960

Second edition 1969

Printed in England by Hazell Watson & Viney Ltd, Aylesbury, Bucks

FIFTY MASTERPIECES OF
ANCIENT NEAR EASTERN ART

OUR recovery of the history, languages, life and art of the peoples of the Ancient Near East and their rise and fall, is mostly the result of barely a century of exploration, excavation and study. The new perspectives it has given to our perception of the long sweep of the past, and the new appreciation of our own place in that immense tale of artistic and technological achievement—the continuous thread of which has never been lost—has perhaps only fully begun to penetrate into the public consciousness in our time.

In the Ancient Near East between the eighth millennium B.C. and the conquest of the region by Islam in the 7th–8th centuries A.D., there arose a brilliant and varied complex of cultures in the fertile Mesopotamian valley, the Iranian hills and piedmont, the Anatolian plateau and the Syrian and Palestinian land-bridge which links those areas with the Nile Valley. This booklet is not intended to give, indeed cannot give, a full picture of their development. The objects here illustrated are, of course, merely a selection, and do no more than illustrate a part of the variety and range of the Department's collections. For a complete picture, the student must seek in scholarly text-books elsewhere. Here he will find represented merely some of the choicest but most characteristic specimens of the arts of those regions, which have been acquired at various times by the British Museum. He will be able to follow, however imperfectly, the development of Mesopotamian art from its first flowering under the Sumerians—the first gifted inventors of Mesopotamian writing—through that of the Assyrian and Persian Empires, to the later artistic world of

Palmyra, South Arabia and Sassanian Persia where ancient Oriental traditions meet those of Greece, Rome and Byzantium. By then he will be already on the threshold of the mediaeval world.

R. D. Barnett
Keeper, Department of Western Asiatic Antiquities

The present edition is basically the same as the original, 1960 edition but with substantial revisions of the text. The plates have been revised and have been rearranged in chronological order.

March, 1968 R.D.B.

VARIOUS ANTIQUITIES

CYLINDER SEALS

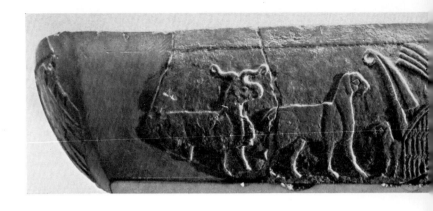

[1]

A Trough from a Sumerian Temple

This is probably a model of a cattle trough presented as an offering in a temple of the Sumerian goddess Inanna (Ishtar). It shows in low relief lambs running out of a reed-hut similar to those of present-day Arabs of the Southern Mesopotamian marshes) to meet the approaching flock. Poles with loop-heads and tassels protrude from the roof of the hut and symbolize the goddess Inanna. On the short sides, ewes browse flowers. From Warka, the ancient Erech (*Genesis* x: 10), some miles up the Euphrates from Ur and on the opposite bank, where, in

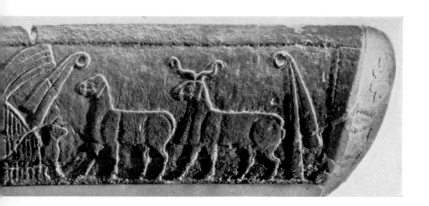

the older Sumerian period, seems to have been the seat of a strongly individual and vigorous school of sculptors.

Jemdet Nasr period, about 3000–2800 B.C.
Gypsum. 16·3 cm high × 103 cm long × 38 cm wide. (A fragment at the end of one long side is a cast, the original part being in Berlin.)
H. R. Hall, *British Museum Quarterly*, III, 1928–29, pp. 40–41, pl. xxii.

[Prehistoric Room 120000]

[2]

A Sumerian Animal Portrait

This ewe's head has a counterpart in a similar piece in sand-
stone found by German archaeologists in an excavation at
Warka and it is possible that the present example is from the
same site. The purpose of these heads is unknown; they may
have been from some furniture or statuary groups, made in
pieces; perhaps they were models for metal-work figures. In
any case, they show well that the freshness and sureness of
modelling of the Sumerian sculptors was already present at this
early date, before the hand of tradition had overlaid the repre-
sentation of animals with the later rigid system of conventions.

From Warka(?), Southern Iraq.
Jemdet Nasr period, about 3000–2800 B.C.
Clay. 9·5 cm high × 13·6 cm long.
T. C. Mitchell, *British Museum Quarterly*, XXIII, 1960–61,
pp. 100–101, pl. xlii b.

[Prehistoric Room 132092]

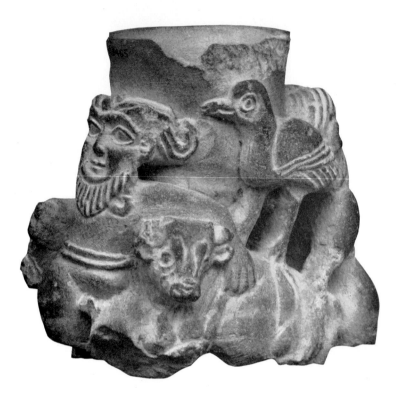

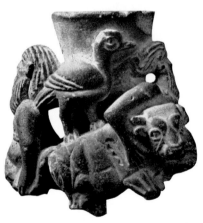

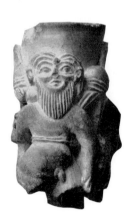

12

A Sumerian Libation Vase

This is one of a type of small conical cup, carved out of a single piece of limestone, with an elaborate supporting group, in such high relief as to be practically in the round. The supporting group consists of a pair of bulls walking in opposite directions, which two bearded demi-gods are shown holding. A bird stands on the back of each bull. This is one of the earliest examples of the subject of the nude hero of the wild countryside struggling with, or protecting, animals, afterwards repeated countless times in Sumerian art.

The cup was probably a gift to a temple and was meant to be used for ritual purposes.

From Warka, Southern Iraq.
Jemdet Nasr period, about 3000–2800 B.C.
12·7 cm high × 7·9 cm wide. *Legs of figures broken off.*
H. R. Hall, *British Museum Quarterly*, II, 1927–28, pp. 12–13, pl. v b.

[Prehistoric Room 118465]

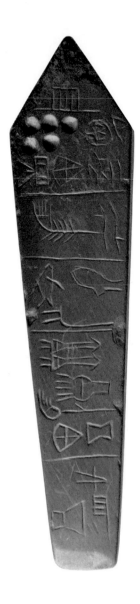
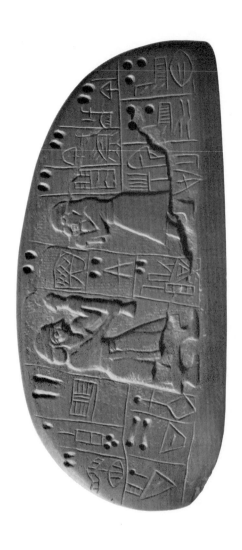

[4]

The 'Blau Monuments'

These two irregularly-shaped stone objects furnish one of the earliest examples of the development of cuneiform writing. The archaic (pictographic) form of the characters is similar to that on the early clay tablets found at a site called Jemdet Nasr, near Kish, in Babylonia. The style of the sculptured figures, engaged in religious ritual or sacrifice, is paralleled in early sculptures found at Warka. The provenance of these important objects is unknown, and they are commonly named after an earlier owner, a Dr. A. Blau.

Early Sumerian, about 2900 B.C.
Green stone.
left: 4·1 cm × 17·8 cm.
right: 7 cm × 15·9 cm.
M. E. L. Mallowan, *Early Mesopotamia and Iran*, London, 1965, pp. 65–67.

[Room of Writing 86260–61]

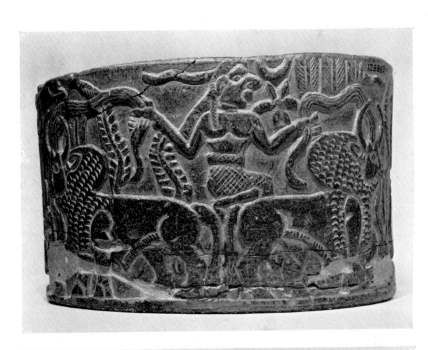

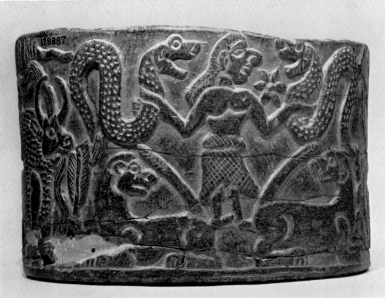

[5]

The Vase of the Snake Deity

The artistic originality of the Sumerians in design, especially that for a circular surface, and their taste for symmetrical composition, is well displayed in this vase, which shows two figures, probably goddesses, amid animals which they dominate as representing the forces of nature and fertility. They are probably both aspects of the great goddess Inanna, later Ishtar, symbolised by the star.

From Khafaje, Central Iraq.
Sumerian, about 2800–2600 B.C.
Steatite. 11·5 cm high × 17·7 cm diameter.
S. Smith, *British Museum Quarterly*, XI, 1936–37, pp. 117 ff.
[Babylonian Room 128887]

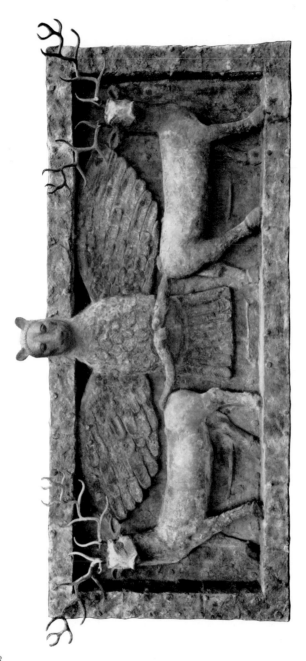

[6]

Copper Panel of Im-dugud

This magnificent example of early Sumerian metal work shows the lion-headed eagle Im-dugud, emblem of Nin-Girsu, chief god of the city of Lagash, gripping with either claw a stag by the tail. The stags belong to the breed known as Oriental red deer.

The panel is built up from sheets of copper, raised and hammered into shape, then riveted and chased, originally over a wooden core coated with bitumen.

It was found in excavations at Al Ubaid, near Ur, in 1919, and once ornamented the façade or doorway of a temple.

From Al Ubaid, Southern Iraq.
Early Dynastic III period, about 2500 B.C.
107 cm high × 238 cm broad. *Head, legs and talons of Im-dugud, hooves of stags, and head and antlers of right-hand stag restored.*
H. R. Hall and C. L. Woolley, *Ur Excavations*, Vol. I, *Al Ubaid*, London, 1927, pp. 22 ff., pl vi.

[Babylonian Room 114308]

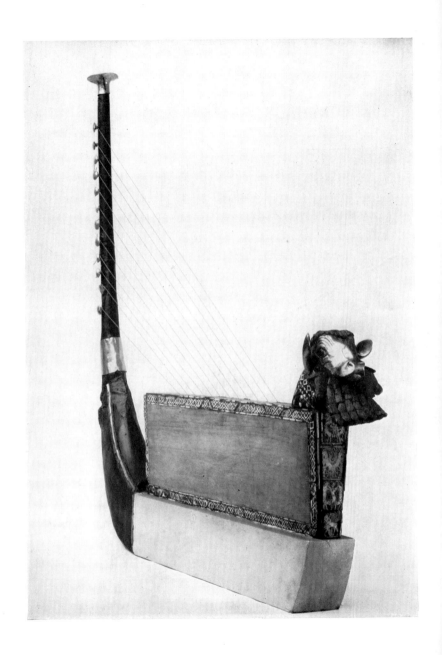

Queen Pu-abi's Harp

Two harps and several lyres, the oldest ever found, were among the rich treasure discovered in 1927 by Sir Leonard Woolley in the Royal Cemetery of the Sumerian Dynasty which ruled Ur ('Ur of the Chaldees', *Genesis* xi: 31) about 2500 B.C.

The harp, triangular in outline, has the strings running obliquely from the horizontal boat-shaped sounding-box to the vertical arm bearing the gold tuning pins. The front of the sounding board is ornamented with a splendid bull's head made of gold sheet hammered over a wooden core, with beard and mane of lapis lazuli; his collar and the edging of the sound-box are of lapis lazuli, red limestone and shell. The front of the sound-box is inlaid with lively scenes of the lion-headed eagle (Im-dugud) clawing at two goats, two bulls nibbling at two trees, a bull-man wrestling with two leopards, and a lion seizing a bull.

(It is now thought that the reconstruction of the harp is wrong in some details. These will be corrected in due course.)

Found with the bodies of serving-men and women in the entrance passage leading to the tomb of Queen Pu-abi, at Ur, Southern Iraq.

Sumerian, about 2500 B.C.

107 cm high.

Sir L. Woolley, *Ur Excavations*, Vol. II, *The Royal Cemetery*, London, 1934, pp. 249 ff, pls. 100, 104, 108–10.

[Babylonian Room 121198]

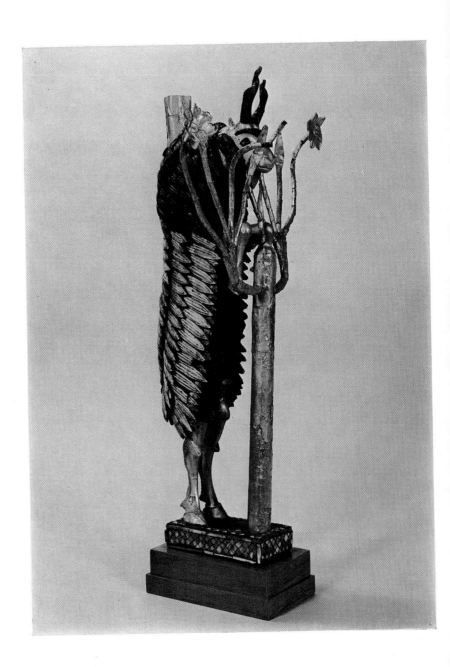

[8]

The Goat and the Tree

Statuette of a he-goat, rearing up on its hind legs to sniff at the flowers on a tree. The tree is of gold leaf, the goat has face and legs of gold leaf, the horns, eyes, and shoulder fleece being of lapis lazuli, while the body fleece is made of white shell. It was originally mounted on a core of wood, now perished.

The pedestal is of silver, with mosaic work in shell, lapis lazuli and red limestone.

This figure is part of a symbolic composition in which two goats climb up towards the shoots of a sacred tree in the contrasted heraldic manner beloved by the Sumerians. The exact meaning of this composition is not known, but is probably mythological.

The companion goat to the present piece found with it is in the University Museum, Philadelphia. The motif of two goats about the Sacred Tree, of which this is one of the earliest and liveliest illustrations, is repeated countless times in later Mesopotamian art. A tube growing from each goat's shoulders shows that this group formed the support for some object of furniture.

Found at Ur, in the great 'Death-Pit' beside the Royal tomb (PG. 1237) where seventy-four men and women servants were buried with many gifts.
Sumerian, about 2500 B.C.
45·7 cm high.
Sir L. Woolley, *Ur Excavations*, Vol. II, *The Royal Cemetery*, London, 1934, pp. 121, 264, pls. 87, 88, 90.

[Babylonian Room 122200]

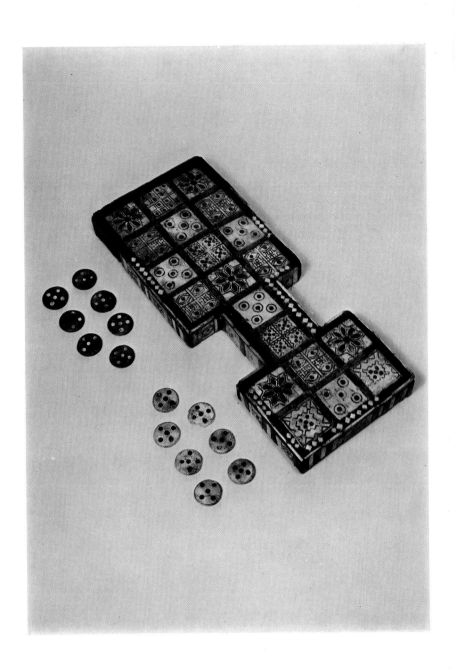

[9]

A Sumerian Game

Gaming board, made originally of wood now perished, en-
crusted with a mosaic of shell, bone, lapis lazuli, red paste, and
red limestone, set in bitumen. From Sumer this game seems to
have travelled to the East, for a game on a board of somewhat
similar shape is played in Ceylon. This game was also carried
to the Levant Coast, as an ivory board of this shape was found
in excavations at Hamath in a level of the 8th century B.C.

The plaques are decorated with a variety of patterns in which
an eye or pair of eyes is conspicuous. The underside has a
different inlaid pattern, not unlike that on a modern back-
gammon board, and may have been used for a second game.

The board was originally hollow, in the form of a box, the
gaming pieces being kept inside it. There are seven gaming
pieces for each of the two players.

From a grave (PG/513) in the Royal Cemetery at Ur.
Sumerian, about 2500 B.C.
29·8 cm long × 12 cm wide.
Sir L. Woolley, *Ur Excavations*, Vol. II, *The Royal Cemetery*,
London, 1934, p. 276, pl. 95.
H. J. R. Murray, *A History of Board-Games other than Chess*,
Oxford, 1952, pp. 19–21.

[Babylonian Room 120834]

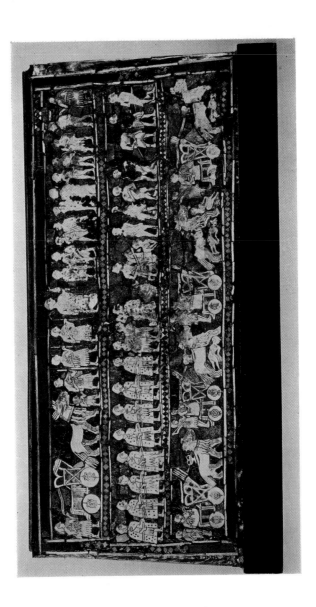

The 'Standard of Ur'

A hollow receptacle, originally of wood, first thought to be a standard. It is shaped like a two-sided lectern-top, ornamented on four sides with scenes in a gaily-coloured mosaic of shell, red limestone and lapis lazuli, inlaid in bitumen. The two main sides, each in three registers, depict War and Peace.

P. 26: WAR. The Sumerian King, his infantry and chariot oppose the enemy: the Sumerian pikemen and chariotry charge, rout and despoil the enemy.

P. 28: PEACE. The King banquets, enthroned amid his nobles, to the sound of music and chant. Tributaries, slaves or prisoners bring wealth in the form of cattle, asses or other gifts.

The end panels show rustic scenes and wild or mythical animals.

This vigorous illustration of Sumerian life has been described by its discoverer as 'the most elaborate piece of mosaic and one of the most remarkable and important objects that the soil of Mesopotamia has preserved to us'.

From Ur, grave-pit 779, chamber 9. Found by the right shoulder of a man lying in the corner of the chamber.
Sumerian, about 2500 B.C.
20·3 cm high × 48·3 cm long. *The woodwork and some inlays restored.*
Sir L. Woolley, *Ur Excavations*, Vol. II, *The Royal Cemetery*, London, 1934, pp. 61–62, pls. 90–93.

[Babylonian Room 121201]

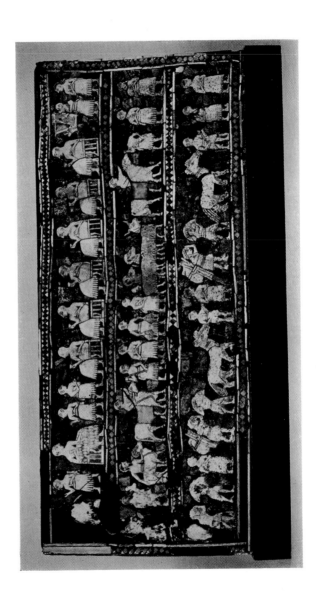

28

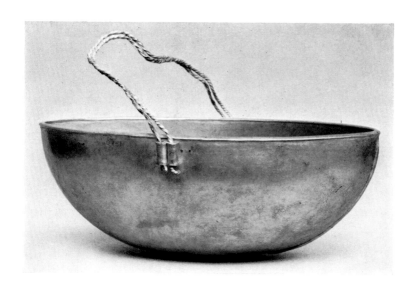

[11]

The Queen's Gold Bowl

This bowl is boat-shaped, but its sides are plain except for two double lugs, which serve for suspension by means of a twisted gold wire.

Found with a drinking-tube or 'straw' of silver beside Queen Pu-abi's head on her bed in the Royal Cemetery of Ur.

Sumerian, about 2500 B.C.
Gold. 7 cm high × 19·7 cm long × 11 cm wide.
Sir L. Woolley, *Ur Excavations*, Vol. II, *The Royal Cemetery*, London, 1934, p. 80, pl. 161.

[Babylonian Room 121344]

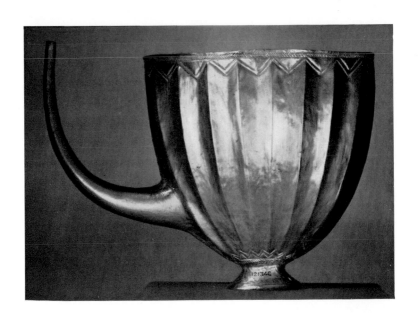

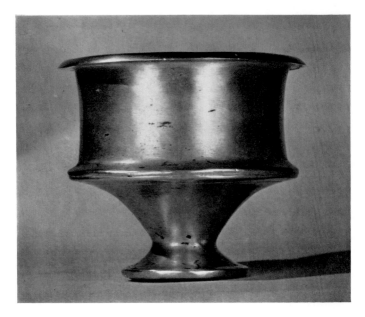

Queen Pu-abi's Gold Feeding Cup and Goblet

This spouted feeding cup, of narrow oval section (viewed from above), has elegantly fluted sides, the lip ornamented with herring-bone and double zigzag patterns, and a small pedestal foot.

The goblet has a curled lip and vertical profile running out to a ridge from which it tapers sharply to a neat foot. It contains a quantity of the Queen's green eye-paint.

From the death-pit at the entrance to the grave of Queen Pu-abi at Ur. Two of four gold vessels found close together with many other treasures beside the remains of the Queen's wardrobe-chest.

Sumerian, about 2500 B.C.

FEEDING CUP: 12·4 cm high; rim, 12 cm × 7 cm; base 4·1 cm × 2·4 cm.

GOBLET: 8·8 cm high; rim, 10·2 cm diam.; foot 5·1 cm diam.

Sir L. Woolley, *Ur Excavations*, Vol. II, *The Royal Cemetery*, London, 1934, p. 82, pl. 161.

[Babylonian Room 121346, 121345]

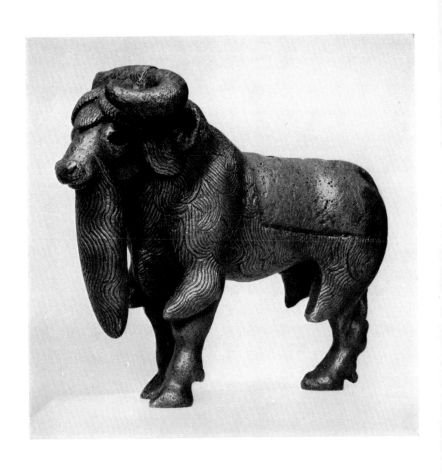

Copper Figure of a Bison

This vigorous sculpture represents the almost extinct European bison which, till recently, survived in the Caucasus and Poland, but now is preserved only in captivity in Northern Europe. The figure, being clearly modelled from memory, though very lifelike, is not quite exactly rendered, since an actual bison wears a shaggy beard, but one less long and does not carry his head so high.

The bared portion of the bison's haunches probably was originally covered by a separately-made base and figure of a god, now lost, who stood on the animal's back. This is a method of representing gods in relation to their favourite animal which is well known in Mesopotamia.

Said to have been found at Van (Eastern Turkey), whither it may have been exported in antiquity.
Sumerian, Early Dynastic or Sargonic period, 2500–2250 B.C.
Solid copper, cast and chased. 12 cm high × 15·5 cm long.
Right horn and left hind hoof missing.
R. D. Barnett, *Compte-Rendu de la IIIe Rencontre Assyriologique Internationale*, Leiden, 1952, pp. 10–18, pl. 1.

[Babylonian Room 108813]

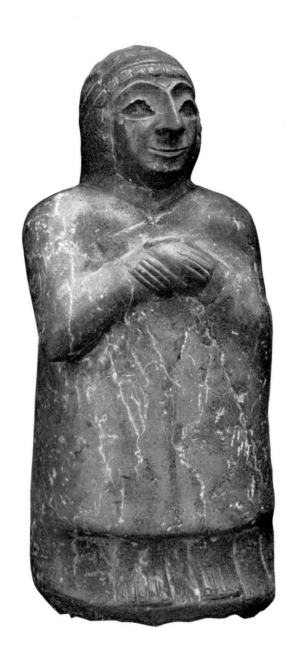

A Sumerian Lady

This charming figure represents a lady of the Early Sumerian period, with her hair falling on her shoulders and held round her forehead by a band, engaged in worship. Already, the Sumerian artist shows the capacity for understanding and depicting the subtleties of the human face, and has a feeling for sculptural form.

It was intended to be dedicated and set up in a temple, where it would perpetually pray to the god for the welfare of the lady whom it represented.

From Tello, Southern Iraq.
Sumerian, about 2450 B.C.
Limestone. 30 cm high.
H. R. Hall, *Babylonian and Assyrian Sculptures in the British Museum*, Paris, 1928, p. 29, pl. v.

<div align="right">[Babylonian Room 90929]</div>

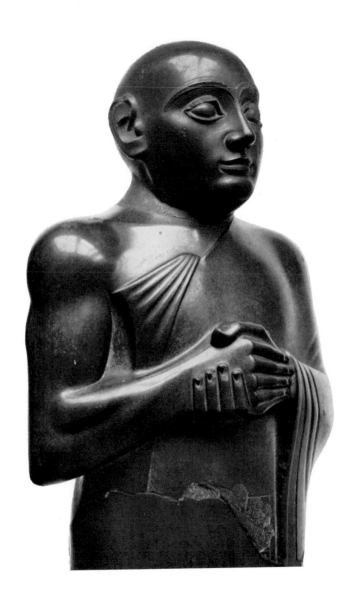

A Sumerian Ruler

This is a fine example of Sumerian portrait sculpture at its best. It is one of a series of statues representing Gudea, ruler of the city-state of Lagash, here piously standing with hands folded in worship in the presence of his deity, in whose shrine it was doubtless dedicated. His head is shaven in the Sumerian manner, and he wears a skilfully represented woollen shawl. There is some evidence that the fingernails were originally gilded. The monumental calm and dignity of this figure, combined with the masterly treatment of the hard material, place it high among ancient works of art.

From Tello, Southern Iraq.
Sumerian, about 2100 B.C.
Diorite. 73·6 cm high. *Lower portion of figure lost: head broken at neck and re-joined.*
Purchased with the aid of the National Art Collections Fund.
H. R. Hall, *British Museum Quarterly*, VI, 1931, p. 31, pl. xiii.

[Babylonian Room 122910]

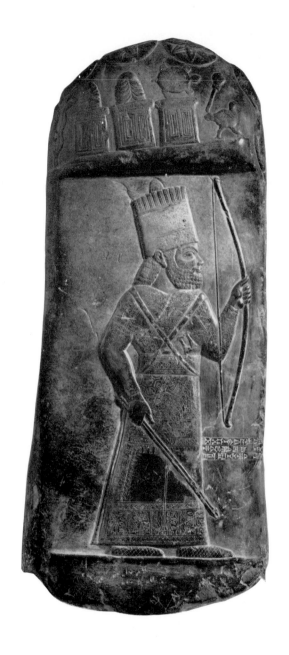

Portrait of a Babylonian King

Boundary stone recording the conveyance of a field on the Shumundar Canal to Marduk-nasir, the king's officer, from Amel-Enlil of Bit-Hanbi, the purchase being paid in kind, amounting in total value to 716 shekels (about 12 lbs.) of silver.

On the top are symbols of twelve gods invoked in the document. Below them is the figure of the king of Babylon, in whose reign the deed was drawn up, Marduk-nadin-ahhe (about 1100 B.C.), resplendent in his embroidered state robes and crown, holding bow and arrows.

Portraits of Babylonian monarchs have survived only in very rare examples.

Babylonian, about 1100 B.C.
Black limestone: 61 cm high × 25·1 cm at base, tapering to 21·5 cm at top.
Presented by Sir Arnold Kemball, 1863.
L. W. King, *Babylonian Boundary Stones and Memorial Tablets in the British Museum*, London, 1912, pp. 37 ff., pls. liii–lxvi.

[Room of Writing 90841]

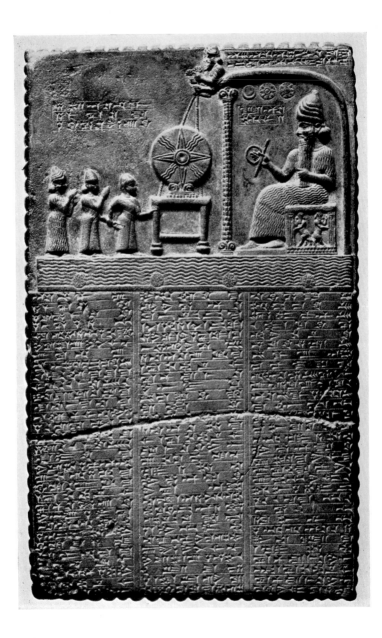

The Sun-God Tablet

This tablet bears an inscription in cuneiform stating that it was dedicated by Nabu-apla-iddina, a king of the Eighth Dynasty of Babylon (about 870 B.C.) who restored the temple of the Sun-God (Shamash) in the city of Sippar in Babylonia.

The temple had fallen into decay and had been pillaged by Aramaean tribesmen, the Sutu; the image of the Sun-God had been destroyed, and all worship had ceased. Nabu-apla-iddina remade the cult image and emblems after a clay model which he discovered on the west bank of the river, renewed the cult with gifts of clothing, and endowed it with estates.

Nabopolassar (626–605 B.C.) later made a clay impression of the tablet and presented fresh gifts of clothing to the god.

The scene above the inscription shows the figure of the Sun-God in his shrine. Before it, two servant-gods hold a huge sun-symbol on a stool, and a priest and a goddess are shown introducing the king into its presence. The shrine is represented resting on the heavenly ocean. In the background are symbols of the Moon, Sun, and the goddess Ishtar (the planet Venus). Examples of the art of Babylon from this period are, in any case, rare. This piece having a ritual purpose reproduces closely the art of Babylon of a much earlier period.

Found together with two clay moulds in an earthenware box with lid buried in the floor of a room of the temple near the Ziggurat at Sippar (Abu Habbah) in 1881.
Babylonian, about 870 B.C. Grey stone. 29·5 cm × 17·8 cm.
L. W. King, *Babylonian Boundary Stones and Memorial Tablets in the British Museum*, London, 1912, pp. 120 ff., pls. xcviii–cii.
[Babylonian Room 91000]

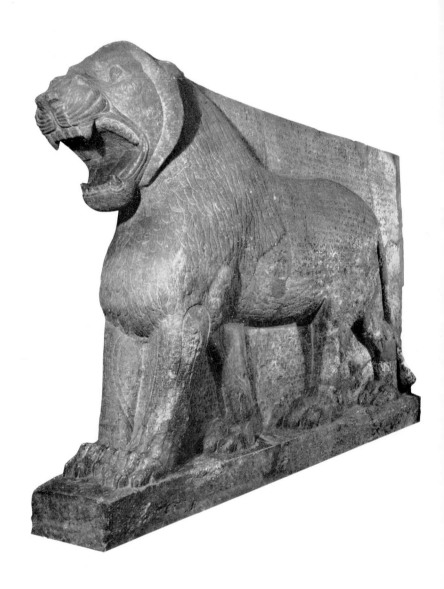

An Assyrian Lion

This magnificent carving of a gigantic standing lion, roaring angrily, formed one of a pair of such figures carved half in the round, which once flanked the entrance of a small temple dedicated to the goddess Ishtar, 'Lady of the Land', adjoining the so-called North-West Palace of King Ashurnasirpal at the Assyrian capital of Calah (the modern Nimrud in Northern Iraq). The temple was found in 1849 by the great English excavator, Austen Henry Layard (later Sir A. H. Layard), who could be justly described as the father of Assyrian discovery.

The custom of placing figures of lions beside the doors of temples or the gates of cities was very ancient in Mesopotamia, and was also practised in Syria and amongst the Hittites.

Lions were common in ancient times in Mesopotamia; indeed, they survived there until the late nineteenth century.

The fifth leg with which this figure has been endowed is an artistic convention to enable the figure to be seen either from the side, walking, or from in front, standing.

The figure is covered with an Assyrian dedication in cuneiform, consisting of a prayer by Ashurnasirpal to the goddess Ishtar, followed by a record of his deeds.

From Nimrud, Northern Iraq. *Assyrian*, 859 B.C.
Gypsum. 259 cm high × 396 cm long.
C. J. Gadd, *The Stones of Assyria*, London, 1936, pp. 126-127. Translation of the inscription: D. D. Luckenbill, *Ancient Records of Assyria and Babylonia*, Vol. I, Chicago, 1926, §§ 521–524. [Assyrian Transept 118895]

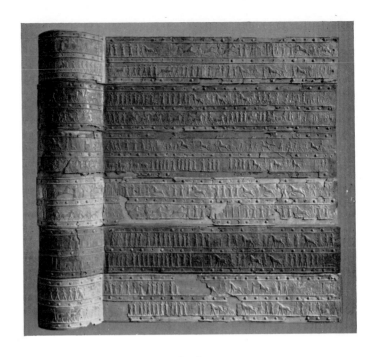

[20]

The Bronze Gates of Shalmaneser

These are the strips once used to sheath the wooden framework of a pair of monumental gates, set up by Shalmaneser III, in a temple dedicated to Mamu, the god of dreams, in a city called Imgur-Enlil, now the little site of Balawat. They depict, in horizontal friezes, the king's expeditions and victories over his various enemies in Armenia, Northern Syria, Phoenicia and Mesopotamia between 858 and 848 B.C., which may be identified from the short cuneiform inscriptions cut above each strip. In technical skill, the work of these gates ranks very high.

The ethnographical information about the king's opponents,

44

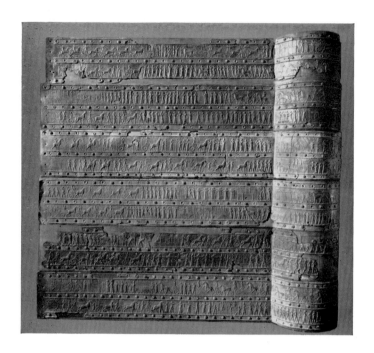

their dress, the appearance of the cities, the military information about their arms and army and those of the Assyrians, is of great value.

The gates were excavated by H. Rassam in 1880 at Balawat. Recent excavations re-opened at the same site by Professor M. E. L. Mallowan, and further work on material in the British Museum have disclosed the existence of at least two more pairs of similarly ornamented gates from the time of an earlier king, Ashurnasirpal II (883–859 B.C.).

From Balawat, near Mosul, Northern Iraq.
Assyrian, about 850 B.C.
Average height of each strip: 27 cm.
L. W. King, *Bronze Reliefs from the Gates of Shalmaneser*, London, 1915. [Assyrian Transept]

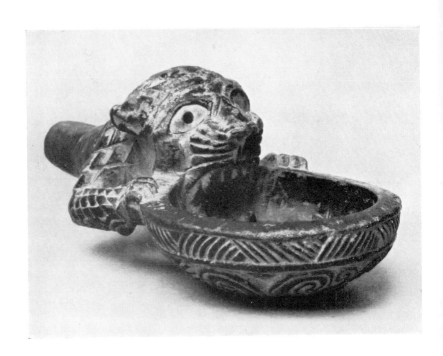

A Syrian Lion-bowl

Both the Hittites and the peoples of Syria in the second millennium B.C. had the happy idea of making a stopper to a vase which could be used in effect as a cup. Sometimes they modelled it in the form of a human hand, sometimes, as here, as a bowl grasped by a thirsty lion which when the vase was inclined, could seem to spew out the liquid, oil or wine or other more precious fluids, or swallow back the remnant.

The present example is the finest and most spirited of its kind. The eyes are inlaid with white stones; the underside of the cup is carved with a beautifully stylized floral pattern, representing the 'Sacred Tree'. The lion's fur is depicted by a neat pattern of tufts resembling scales.

Provenance unknown.
Syrian, 9th–8th century B.C.
Greenish black steatite. 14 cm long × 5 cm high × 7 cm wide.
R. D. Barnett, *The Aegean and the Near East: Studies presented to Hetty Goldman*, Locust Valley, New York, 1956, p. 236, pl. xxiii, 2.

[Hittite Room 132056]

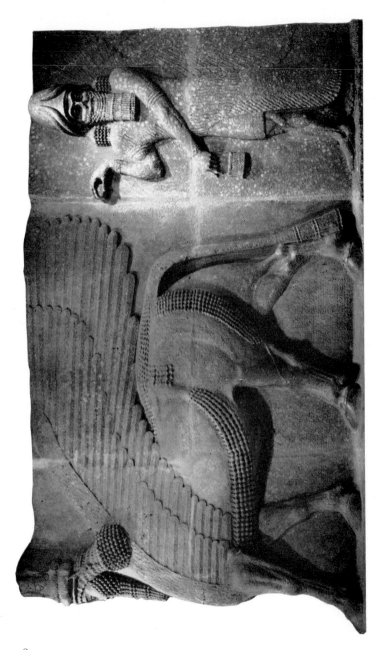

An Assyrian Gateway Colossus

Most imposing of all Assyrian sculptures are the colossal and fantastically-shaped figures of bulls and lions which were habitually placed at the sides of doorways leading into temples and palaces. Generally there was only a single pair, but at very elaborate entrances several might be combined into a group, sometimes with a gigantic demonic figure. The monument illustrated here is one of a pair of human-headed bulls wearing divine head-dresses, attended each by a winged human figure holding a bucket and cone, apparently containing magical unguents with which they anoint the monster before them.

The sculptures were found by the French excavator, P. E. Botta, in his excavations in 1843–44 at Khorsabad, a mound near Mosul in Iraq, covering the great palace called Dur-Sharrukin, 'Fortified city of Sargon', built by Sargon II, king of Assyria, 722–705 B.C. Here they formed a gateway in the wall of the citadel. Acquired in 1849 by Colonel (afterwards Sir) Henry Rawlinson and offered by him to the Museum.

The bulls bear a long cuneiform inscription in which Sargon describes his conquests, the building and dedication of his palace, and ends with a prayer for his own welfare, and a curse on anyone who injures his statues or reverses his enactments.

Assyrian, late 8th century B.C. Gypsum. 442 cm high.
C. J. Gadd, *The Stones of Assyria*, London, 1936, pp. 159–160.
Translation of the inscription: D. D. Luckenbill, *Ancient Records of Assyria and Babylonia*, Vol. II, Chicago, 1927, §§ 91–94.
[Assyrian Saloon 118808]

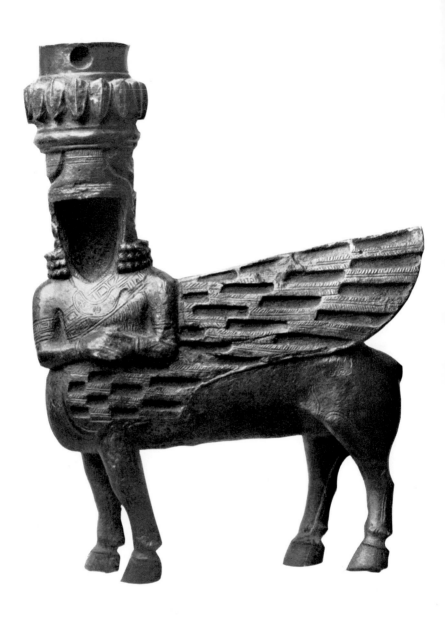

A Figure from a Divine Throne

This monster is closely akin to the Assyrian and Babylonian demonic figures assigned the duty of protecting palace door-ways from evil influences. It shows a winged bull with human head, arms and torso, wearing Urartian dress, but a divine crown, the human body turned towards the spectator with hands clasped in a ritual gesture. The face, which was originally inlaid, perhaps in ivory, is lost. The wings too were once inlaid with coloured glass or stone, and the whole covered with gold leaf, traces of which remain. The figure was one of a number of bronze figures, representing demons and lesser gods, which ornamented the once splendid bronze throne of the god Haldi in his temple at Rusahina by Lake Van (Eastern Turkey). The figure is actually a sort of caryatid, and the floral member on the bull-man's head acts as a capital to support the horizontal beam above. On the top of the capital are some Urartian hieroglyphs which were not intended to be seen.

The piece is a splendid example of Urartian metal working, though in style it does not greatly differ from Assyrian art. It was cast originally in a mould made in several solid pieces, which were then fitted together.

From Toprak Kale, Van, Eastern Turkey.
Late 8th century B.C.
Bronze. 21·6 cm high × 17·8 cm long.
R. D. Barnett, 'Excavations of the British Museum at Toprak-Kale, near Van,' Iraq, XII, 1950, p. 6, pls. vi–vii.

[Babylonian Room 91247]

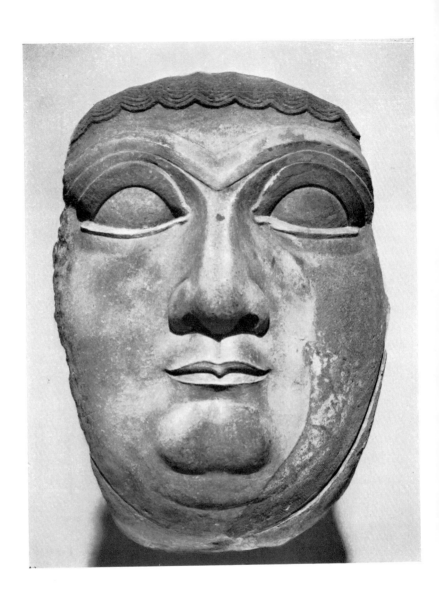

[24]

A Colossal Face

Face of a colossal beardless figure of stern expression, perhaps from a cult statue, or from another figure, such as a sphinx, used architecturally to ornament a palace gateway.

Provenance unknown.
Assyrian, probably 8th century B.C.
Limestone. 45·7 cm high.
C. J. Gadd, *The Stones of Assyria*, London, 1936, p. 164.

<div align="right">[Assyrian Saloon 118909]</div>

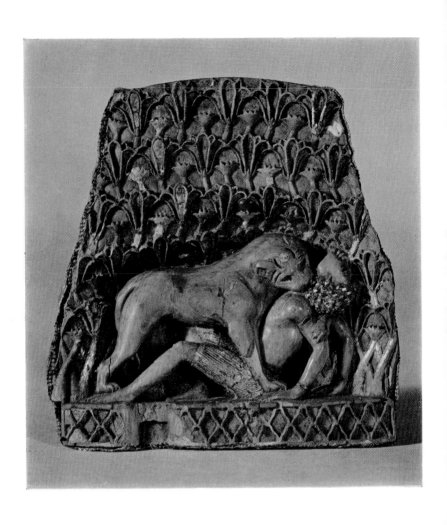

[25]

A Phoenician Ivory

This carved ivory panel is one of a pair which are of a quality unsurpassed in ancient ivory work. The lithe figure of the lioness bites in the throat the hapless negro, who half sinks, half rises, agonised and contorted, and forms with him a tight dramatic group, at once fascinating and repellent. This scene is shown taking place in the depths of a fantastic bower or jungle of stylised flowers, inlaid with blue frit and red carnelian, their stems gilded.

This pair of sculptures (the companion piece is in Baghdad), were evidently from a single piece of furniture of Phoenician manufacture; the authorship is confirmed by a Phoenician letter on the top. They were found—with other ivories— by Professor M. E. L. Mallowan in 1951—in the sludge at the bottom of an ancient well 70 metres deep in Room NN in the North-West Palace of Ashurnasirpal at Calah (Nimrud), where they had apparently been thrown, in a sack of the palace in the early 7th century B.C.

These ivories, with the objects to which they belonged, had probably been carried off by the Assyrians as loot from a Phoenician or Syrian city.

From Calah (Nimrud), Northern Iraq.
Phoenician, 8th century B.C.
10·2 cm high × 10·2 cm wide.
R. D. Barnett, *Catalogue of the Nimrud Ivories in the British Museum*, London, 1957, p. 190 (O 1) and frontispiece.

[Syrian Room 127412]

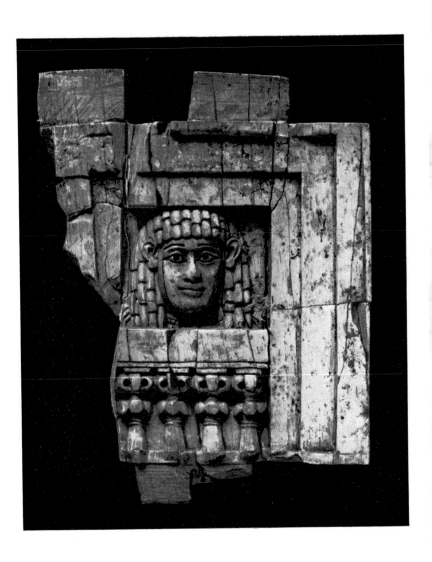

[26]

'The Woman at the Window'

This panel is from a couch, originally carved with ritual figures. It bears a representation of a goddess, known in Assyria as 'Kilili of the window', a form of the goddess of love (Ashtart in Syria and Phoenicia). The goddess, in the guise of a sacred harlot, is looking out of an upper window, the sill of which is supported on small columns. Such a window was called Tyrian. She wears a heavy Egyptian wig, a necklace and a fine crinkly linen garment. (On the reverse is a Phoenician letter to guide the cabinet-maker in construction.)

From Calah (Nimrud), Northern Iraq.
Phoenician, late 8th century B.C.
8·9 cm square.
R. D. Barnett, *Catalogue of the Nimrud Ivories in the British Museum*, London, 1957, p. 172 (C 12) and pls. iv and cxxxii.

[Syrian Room 118159]

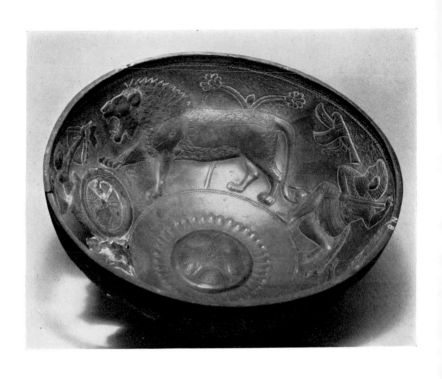

A Phoenician or Syrian Bowl

This deep bowl is from a hoard of decorated metal bowls found over a century ago by A. H. Layard in the palace of Ashurnasirpal at Nimrud, whither they had presumably been taken as tribute or booty. It bears an embossed and chased scene of a lion-hunt from the chariot, executed in the partly Egyptising manner of the Levant coastal cities. The art is heavily stylised, though the metal-work technique of the bowl is very skilful. The meaning of this scene, in which a winged sphinx (the Biblical 'cherub')—not visible in this photograph —takes a part, is not wholly clear, but possibly it is a mythological episode of which we possess no account.

From Calah (Nimrud), Northern Iraq.
Phoenician or *Syrian*, late 8th century B.C.
Bronze. 21 cm diam. × 8·2 cm high.
H. Frankfort, *The Art and Architecture of the Ancient Orient*, London, 1954, p. 197, pls. 172–173.

[Syrian Room 118780]

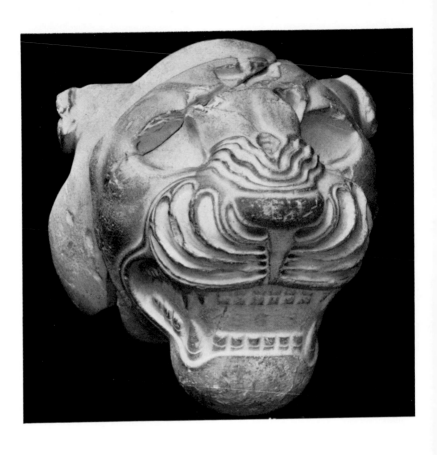

A Lion's Head

This lion's head is very probably from one of the ornamental arms of a throne. Its eyes were once inlaid, and tufts of hair (or stones to represent them) were inserted over the brows. Though conventionalised in the extreme as a result of a tradition of centuries of representing lions, yet, with its wicked, wrinkled snarl this piece must have been very effective. It is a rare example of Late Babylonian art, the greater part of which is lost.

From Sippar (Abu Habbah), Babylonia.
Babylonian, 8th–7th century, B.C.
White stone. 10·2 cm high.
H. R. Hall, *Babylonian and Assyrian Sculptures in the British Museum*, Paris, 1928, p. 50, pl. lix.

[Babylonian Room 91678]

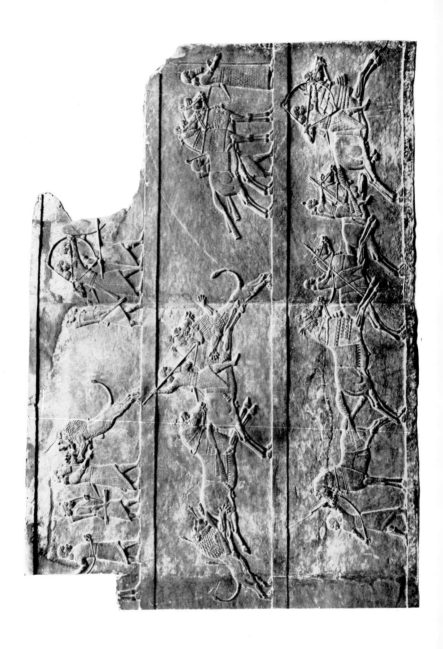

The Assyrian Lion Hunt

The Assyrian palaces of the 9th–7th centuries B.C., ornamented with colossal figures of monsters guarding their doorways, were also decorated with elaborate pictorial scenes within. Such scenes usually depicted the achievements of the king in war or in the chase, or the receipt of foreign tribute. The finest of all the series of scenes and the latest (so far as is known) was found in 1854 by W. K. Loftus, working for the British Museum at the site of Kuyunjik (Nineveh) in the palace of Ashurbanipal—known to the ancient Greeks under the garbled form of Sardanapalos. The present illustration is an excerpt from the hunting scenes of that monarch in which he despatches a lion single-handed (a heroic feat), either on foot or on horseback, while another lion springs upon his spare horse.

The atmosphere of balance and restraint provided by the carefully architectured compositions, the contrast of the animals, wild emotion and swift movements, captured as if by a snapshot, matched and contrasted with the almost static poses and calm composure of the king and his huntsmen, achieve a monumental dignity that represents the high water mark of ancient Near Eastern narrative art.

Assyrian; from the North Palace or palace of Sennacherib at Nineveh, about 650 B.C. Gypsum. 167·6 cm high.
C. J. Gadd, *The Stones of Assyria*, London, 1936, pp. 184–185.
R. D. Barnett, *Assyrian Palace Reliefs*, London, 1960, pp. 22–23, pls. 83–84.

[Assyrian Saloon 124875–6]

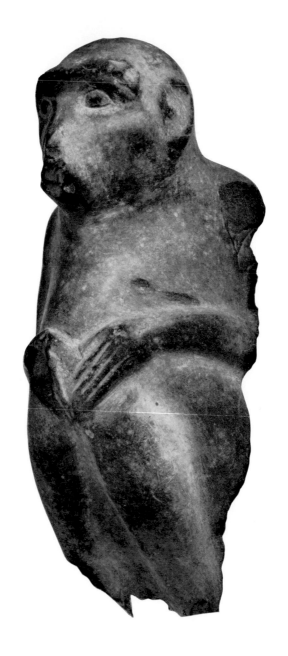

64

[30]

Figure of a Monkey

This cleverly observed study of a monkey, carved in hard stone, with hands characteristically laid over its stomach, is unique in the land of Ancient Mesopotamia. The slightly turned face gives it an air of alertness and naturalness. The monkey, an animal which is not native to Mesopotamia, was imported in antiquity, probably by the Phoenicians. It seems to have been regarded with some awe, as representations of it often occur in religious scenes, and some think a symbolic meaning was attached to it.

From Kalaat-Shergat (Ashur).
Assyrian, about 7th century B.C.
Basalt. 19·7 cm high. *Broken in three pieces, rump lost.*

[Babylonian Room 116388]

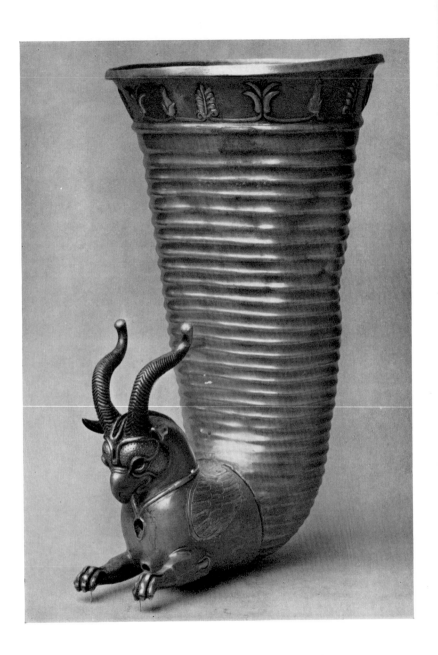

[31]

A Persian Drinking Horn

This vessel is a reproduction in metal of a drinking vessel made originally from a cow's or similar animal's horn. Such drinking vessels appear to have been a Persian speciality for some centuries; under the Persian Empire the use of them spread further afield, for example, to the Greek cities of Asia Minor. The hole in the animal's chest suggests it was the custom to drink the jet of wine from it without touching the vessel with one's lips, as the Spaniards today do from a *porrón*.

In the present example, the horizontally fluted bowl is fitted into a finely made figure of a crouching griffin of Persian type. It is horned and vulture-beaked, wearing a necklet which once bore an inset jewel. Its eyes, too, now empty, once held gems, and an upright mane or crest, now missing, rested in a deep channel on the neck.

Found at Erzincan, in North Eastern Turkey.
Persian, 5th century B.C.
Silver, parcel-gilt. 25 cm high.
O. M. Dalton, *The Treasure of the Oxus*, 3rd edition, London, 1964, pp. 42–43, no. 178, pl. xxii.

[Persian Landing 124081]

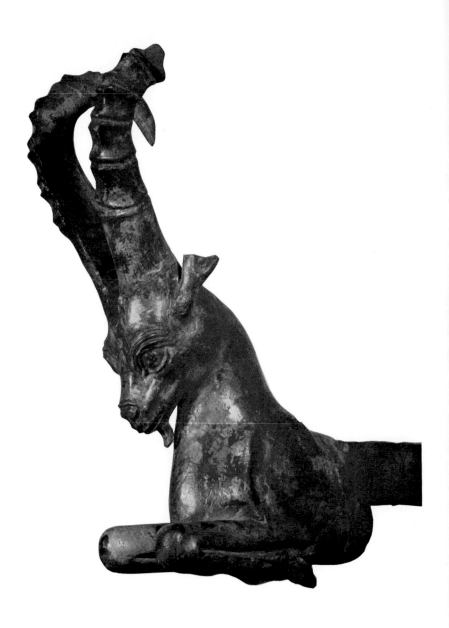

[32]

A Leaping Ibex

This handsome representation of a leaping ibex belongs to the Achaemenid period, the most polished and sophisticated age of Mesopotamian art, and the last in the great tradition begun by the Sumerians. But it still is infused with a sense of suppressed vigour and can justly claim to be part of a lost masterpiece possibly of metal work. It is likely that it was the handle, or at least the ornament, of some great monumental vase, or very possibly the ornament of a divan, into which it was fitted by the long tongue projecting from the back of the animal.

The subject of the leaping goat or ibex is popular in this period.

Persian, about 5th century B.C.
Bronze. 17·8 cm high × 17·8 cm long.
C. J. Gadd, *British Museum Quarterly*, XV, 1950, p. 58, pl. xxv.

[Persian Landing 130674]

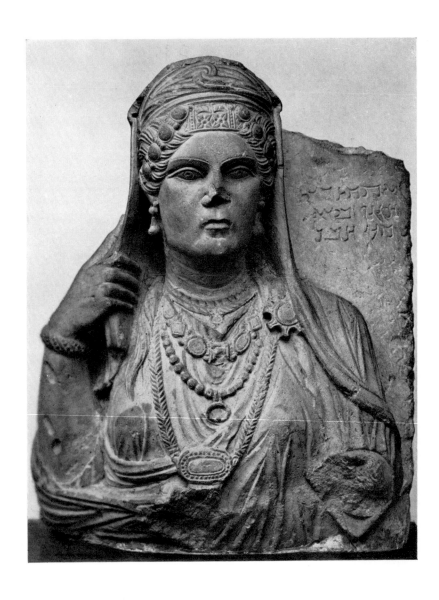

[33]

A Palmyrene Lady

Palmyra, whose modern Arabic name, Tadmor, occurs in the Old Testament and, as Tadmar, in cuneiform sources of the 2nd and 1st millennia B.C., is an oasis in the centre of the Syrian desert. It linked in antiquity the traffic of Syria passing from Damascus and Emesa with the trade of Babylon and the Eastern regions beyond. In Roman Imperial times, Palmyra grew to be a wealthy and powerful independent principality. Among its many fine surviving monuments, the burial towers, in which the wealthy families deposited their dead, are noteworthy. The tombs which these contained were usually provided with a portrait bust of the deceased, carved in limestone and usually originally enlivened with colour.

The present portrait is of a handsome young woman of good family, elaborately dressed, with jewellery and other finery of Oriental fashion. But in her restrained and sensitive movement we may feel the breath of Hellenistic Greek art. Above her portrait is written her name and pedigree in Palmyrene—(a dialect of Aramaic): 'Aqmat, daughter of Hagago, son of Zebida, son of Maan. Alas!'

From Palmyra, Syria.
Late 2nd century A.D.
Limestone. 50 cm high.

[Syrian Room 102612]

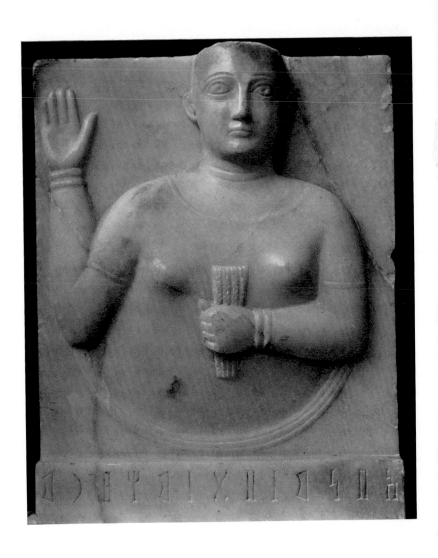

[34]

A South Arabian Lady

The gravestone of a young woman named Aban, of the clan of Mahdar, who probably lived in Qataban, an ancient kingdom of South Arabia lying N.E. of Aden, once fertile and populous. The kingdoms of Southern Arabia, which flourished in particular by reason of the trade in incense grown there and the transit trade to India, were inhabited from early times by tribes speaking a Semitic language close to Arabic. They used an elegant alphabetic script peculiar in form to the Arabian peninsula, and possessed a distinct culture of their own.

This lady is represented staring firmly to the front (as is common in the contemporary art of Palmyra and Dura, and later becomes accepted in Byzantine art) reclining with a coverlet over her waist, and holding a bunch of cornstalks in her hand. The top of her head, as is usual in South Arabian portrait busts, is planed off horizontally, perhaps to be fitted with some adjunct to represent hair or a head-dress. The stiff and stylised character of the figure is softened by the smooth, polished and rounded surfaces and the pleasing curve of the coverlet.

Provenance unknown.
South Arabian, about 2nd century A.D.
Calcite. 32·4 cm high × 25·7 cm wide.
R. D. Barnett, *British Museum Quarterly*, XVII, 1952, pp. 47–48, pl. xx a.

[Syrian Room 130880]

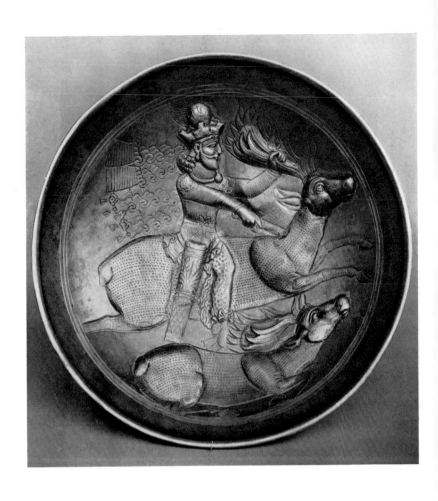

[35]

Sassanian Hunting Scene

A shallow drinking bowl of silver, parcel gilt, is ornamented with a scene showing a Sassanian king astride a great stag which he is stabbing through the shoulders as it gallops. Below is crouching a second stag, apparently dying.

The king wears trousers, and an elaborate crown with streamers, characteristic of his dynasty, rulers of Persia from about A.D. 250–500. He is probably the great Sapor II (A.D. 310–380) who utterly defeated the Roman Emperor Julian.

The art of the Sassanians was archaistic, being based on ancient oriental themes re-applied. This, for example, certainly revives the theme of the ancient Assyrian hunting scenes. But they were usually re-applied with craftsmanship of a high order, and their works of art are full of movement and interest.

The present bowl is made in a technique invented in Greece but particularly popular among Sassanian silversmiths. The bowl was hammered into shape, then turned on a lathe. The raised parts of the figures, however, were embossed and cut out separately, then soldered on to the background so skilfully that the joins can scarcely be seen. This method has the merit that the back of the bowl is left smooth.

Said to have been found in Turkey.
Sassanian, 4th century A.D.
Silver parcel-gilt. Diameter 18 cm.
O. M. Dalton, *The Treasure of the Oxus*, 3rd edition, London, 1964, p. 60, no. 206, pl. xxxvi.

[Persian Landing 124091]

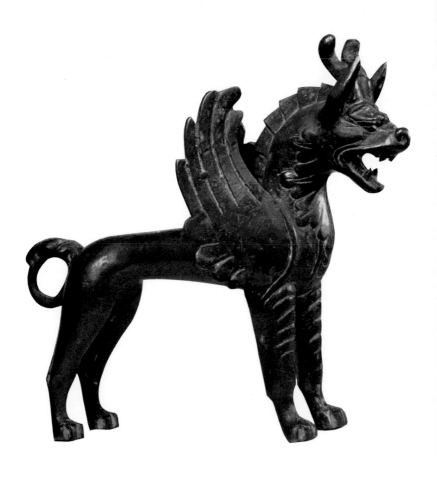

[36]

A Sassanian Monster

The monster, in the form of a winged lion with ears of a horse
and horns of a wild goat, though akin to similar Mesopotamian
creatures, is an invention of Iranian mythology and art, and
probably symbolises Ahriman, the great power of darkness
and evil. This type of monster seems to have spread eastward
as far as China, where it is frequently used to represent a dragon.
The present example is a work marked by spirit and vigour,
even ferocity. The lean body shows the hairs on chest and tail,
stylised most illogically into leaf patterns. The shrunken wing
with curling tip shows the start of a tendency which was
developed in Parthian art.

Said to have been found near the river Helmund, in Afghanistan.
Sassanian, about 4th century A.D.
Cast in solid bronze and chased. 24·9 cm high.
Presented by the National Art Collections Fund.
O. M. Dalton, *The Treasure of the Oxus*, 3rd edition, London,
1964, p. 49, no. 194, pl. xxv.

[Persian Landing 123267]

CYLINDER SEALS

CYLINDER SEALS

THE small engraved cylinder seal is one of the most common and typical objects found in the Near East, especially in ancient Sumer, Babylonia, Assyria and neighbouring countries. The seals, as also the stamp seals which were fashionable at some periods, were engraved with designs which varied not only in workmanship but also in theme, at different places and periods between the fourth millennium B.C. and the end of the Persian Empire in the fourth century B.C.

In prehistoric and proto-literate times, the cylinder seal was mainly used for rolling over any clay surface as a mark of personal ownership. But later, clay being the standard medium of writing, as papyrus was in Egypt or paper is to us, the main use of the cylinder seal was to serve as a signature in witness of an inscribed clay document. Many seals bear incised scenes representing the owner's personal protecting deity; a religious or a mythological scene and (sometimes) the owner's name and the name of the protecting deity. For this reason, and because the diverse stones from which the cylinders were cut were thought to have magical significance, the seals were also used as amulets or, to a lesser extent, as personal ornaments. Herodotus, the Greek historian and traveller, says that every Babylonian had a staff and a seal. The engraver's techniques vary greatly throughout the three thousand years in which the cylinder seal was in use, according to the kinds of stones and tools used. But they provide us, nevertheless, with an important source of material for a study of the history of art. This miniature art is for some periods all, or almost all, that has survived to illustrate the graphic concepts of these periods.

Many symbols and ideas can be traced with its aid through the changing styles of successive periods. Some periods of remark-

ably fine seal engraving (such as those illustrated here by the few examples selected from the Museum's large collection) were followed by periods of decadence. Moreover, at all periods, seals of good and poor workmanship were engraved, so that it is not always possible to decide the exact date or even provenance of a seal, especially of those coming from areas bordering on Mesopotamia which are subject to a number of alien influences.

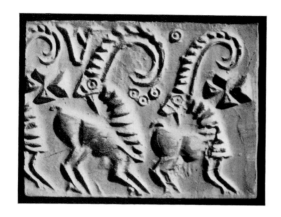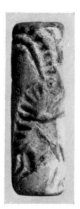

[37]

An Early Cylinder Seal

The impression made by this tall, thin seal brings out vividly the geometrical design which makes the most of the limited space available to the engraver. Two bearded goats are shown in file with 'Maltese' crosses, and 'eyes' as space fillers.

Sumerian, Jemdet Nasr period, about 2900 B.C.
Steatite. 6 cm high × 1·9 cm diameter.
British Museum Quarterly, III, 1929, p. 13, pl. iv.
D. J. Wiseman, *Catalogue of the Western Asiatic Seals in the British Museum. Cylinder Seals*, I, London, 1962, p. 8, pl. 7e.
[Room of Writing 119306]

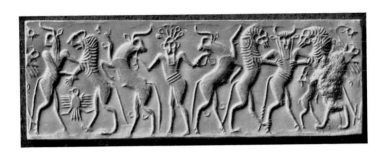

[38]

An early Contest Scene

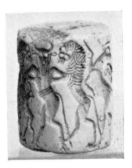

In this seal the nude hero, in the centre, holds a bull in each hand while the bull-man, shown in profile, fights a rampant lion. Between them is a bird with spread wings. To the right, the bull-man, here full-faced, struggles with two lions to rescue an ibex shown between the contestants. An ibex head (above, right) is used as a space filler.

Sumerian, Early Dynastic II, about 2650 B.C.
Aragonite. 4·2 cm high × 3·6 cm diameter.
D. J. Wiseman, *Catalogue of the Western Asiatic Seals in the British Museum*, Cylinder Seals, I, London, 1962, p. 16, pl. 14a.

[Room of Writing 89538]

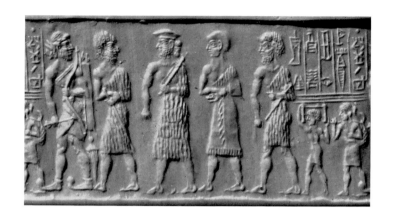

[39]

Seal of the Scribe Kalki

A military figure, possibly the prince mentioned in the inscription, wearing a flat cap and bearing an axe on his left shoulder, is attended by a scribe, two armed body-guards and two porters. The group is led by a bowman, Syrian or Anatolian, who wears shoes with turned-up toes. The porters, bearing furniture and provisions, are depicted on a smaller scale beneath the inscription, which reads:
'*Ubil-Eshtar, brother of the king: Kalki, the scribe is your servant.*'

Akkadian, about 2320 B.C.
Aragonite. 3·4 cm high × 2·1 cm diameter.
H. Frankfort, *Cylinder Seals*, London, 1939, p. 140, pl. xxiv c.

[Room of Writing 89137]

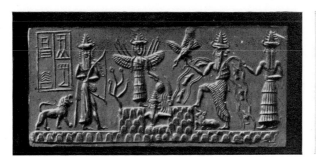
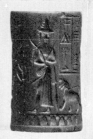

[40]

Seal of the Scribe Adda

The interpretation of this unique mythological scene is uncertain, although the fire deities may be identified. The sun-god, whose rays spring from his shoulder, holds aloft his emblem, the saw, as he rises between two mountains. Ea, god of the Deep (indicated by the flowing waters), steps over a rising bull and holds a bird in his hand. His Janus-headed attendant, Usmu, stands behind. On the mountain, to the left, stands the winged-goddess of war, Ishtar, shown full-faced, carrying quivers on her back and an object (a date-cluster?) in her hand. The tree growing from the mountain is a symbol of fertility. Another god, perhaps Ninurta, advances bow in hand. The scene, often described as a New Year ritual, may illustrate a myth now lost.

The inscription reads: '*Adda, the scribe.*'

Akkadian, about 2300 B.C.
Green schist. 3·8 cm high × 2·5 cm diameter.
H. Frankfort, *Cylinder Seals*, London, 1939, pp. 100 ff., pl. xix a. [Room of Writing 89115]

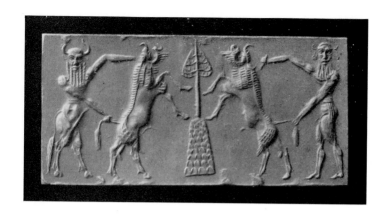

[41]

An Akkadian Contest Scene

A seal with a finely-modelled heraldic group showing a bull-man and nude hero each holding a rampant bull by the horn and tail. The forelegs of the bulls are engraved to make it appear as if they touched the top of a stylised mountain, on which stands a 'sacred tree'. It is sometimes thought that the man may represent Gilgamesh, hero of a series of Sumerian epics, and the bull-man his friend and fellow-adventurer, Enkidu; but such an interpretation is without foundation.

Akkadian, about 2250 B.C.
Greenstone. 3·8 cm high × 2·4 cm diameter.
H. Frankfort, *Cylinder Seals*, London, 1939, pl. xvii h.

[Room of Writing 89308]

87

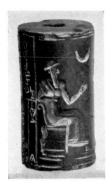
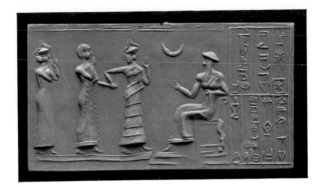

[42]

Seal of a Governor

A typical 'introduction scene'. Hashhamer, governor of the city of Ishkun-Sin, is introduced to the seated king of Ur, Ur-Nammu. The inscription reads: '*Ur-Nammu, mighty man, king of Ur: Hashhamer, the governor of Ishkun-Sin, is your servant.*'

Sumerian, Ur III period, about 2100 B.C.
Green Schist. 5·4 cm high × 3·2 cm diameter.
This is one of the earliest known seals. It was first published in 1820 (in W. Dorow, *Morgenländische Alterthümer*, I, pl. ii) and has been often re-published since.

[Room of Writing 89126]

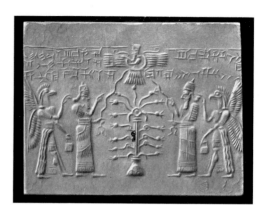

[43] *Seal of Mushezib-Ninurta*

Two figures, in Assyrian dress, represent the king standing beside a 'sacred tree', holding lines streaming from Ashur's winged disk. Behind them stand two bird-headed winged figures. A similar scene was sculptured on the throne-room wall of the palace of Ashurnasirpal II at Calah in 879 B.C. (Nimrud Gallery 124531.) The seal is inscribed: 'Mushezib-Ninurta, a priest, son of the priest Ninurta-eresh, grandson of the priest Shulmanu-haman-ilani.'

In the first year of his reign, Ashurnasirpal II received tribute from Shulmanu-haman-ilani of Shadikanni (modern Arban in N.E. Syria) where Layard discovered winged bulls inscribed 'Property of Mushezib-Ninurta, priest.' The seal was most probably the latter's, although its provenance is Sherif Khan (ancient Tarbisu) on the Tigris.

Assyrian, about 820 B.C.
Chalcedony. 4·9 cm high × 1·7 cm diameter.
H. Frankfort, *Cylinder Seals*, London, 1939, pp. 191 ff., pl. xxxiii a. [Room of Writing 89135]

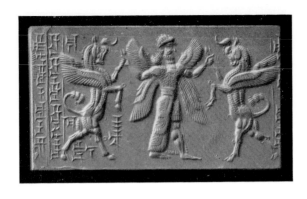

[44]

An Assyrian Seal

A four-winged human figure, with typical Assyrian beard and hair style, grasps two rampant winged bulls. This arrangement of the figures is commonly found in cylinder seals of the period after Sargon II. The inscription is a prayer to the god Nabu.

Assyrian, 8th–7th century B.C.
Jasper. 3·7 cm high × 1·7 cm diameter.
H. Frankfort, *Cylinder Seals*, London, 1939, pp. 204 f., pl. xxxv k.

[Room of Writing 89145]

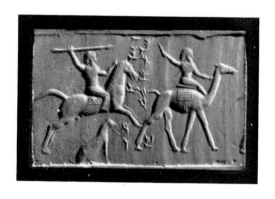

[45]

Seal of Ninurta-ah-iddin

A cavalryman raises his spear to attack an Arab riding on a
camel, perhaps a reflection of Ashurbanipal's campaigns against
the Arabs. A dog squats nearby. The inscription gives the name
of the owner of the seal, Ninurta-ah-iddin, followed by a short
prayer. This finely-engraved seal still retains part of its original
bronze mounting pin.

Neo-Assyrian, 7th century B.C.
Chalcedony. 2·9 cm high × 1·6 cm diameter.
S. Smith, *Early History of Assyria*, London, 1928, pl. xiv b.

[Room of Writing 117716]

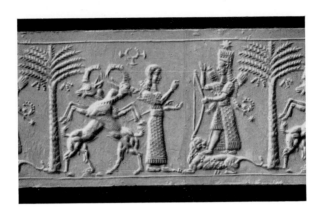

[46]

Ishtar, Goddess of War

A woman with a mace beneath her arm worships Ishtar, the goddess of war, standing upon a crouching lion.

The goddess holds a bow and two arrows and has two full quivers slung over her right shoulder and two maces in her girdle. To the left are two crossed ibexes rampant and a palm-tree. Above the palm-trees is an ear-ring, probably a symbol of the goddess.

This seal is a fine example of the best Assyrian seal-cutting.

Assyrian, 7th–6th century B.C.
Greenish chalcedony. 4·3 cm high × 1·8 cm diameter.
H. Frankfort, *Cylinder Seals*, London, 1939, p. 191, pl. XXXV a.

[Room of Writing 89769]

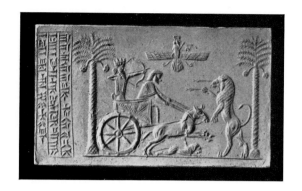 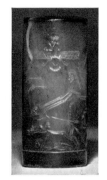

[47]

Royal Seal of Darius

This finely-engraved Persian cylinder seal shows the king hunting lions from his chariot. The palm, or '*sacred tree*' stands in the background. The trilingual inscription gives his name and title ('I, Darius, the Great King') in Old Persian, Elamite and Babylonian cuneiform. There is some uncertainty whether the owner was Darius I (521–485 B.C.) or Darius II (424–404 B.C.).

Probably from Thebes, Egypt.
Persian, 6th–5th century B.C.
Agate. 3·7 cm high × 1·6 cm diameter.
H. Frankfort, *Cylinder Seals*, London, 1939, pp. 14 and 221, pl. xxxvii d.

[Persian Landing 89132]

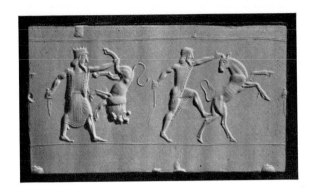 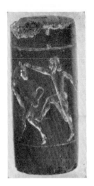

[48]

A Royal Hunt

One of the finest examples of the best work of the period of the Achaemenid Kings. The king holds a lion suspended by its hind leg. On the right, a bearded man with a flail in his hand seizes a bull by its ear.

These subjects are taken over from the repertoire of ancient Assyrian and Babylonian art, to symbolise the triumph of the king over his enemies.

Persian, 6th–5th century B.C.
Chalcedony. 4·8 cm high × 2·2 cm diameter.
First published by C. J. Rich in 1813 (*Mines de l'Orient*, III, pl. ii 6).

[Room of Writing 89337]

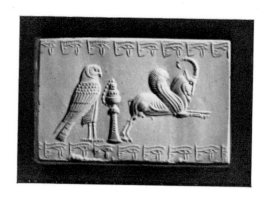

[49]

A Perso-Egyptian Seal

A falcon stands before an incense-burner. To the right, a prancing winged bull with ibex's horns. The border is composed of a repeated *udjat*, the sacred eye of the god Horus and a powerful Egyptian protective amulet. Egypt from the time of the Persian king Cambyses was part of the Persian Empire.

Persian, 5th century B.C.
Chalcedony. 2·5 cm high × 1·1 cm diameter.

[Room of Writing 128865]

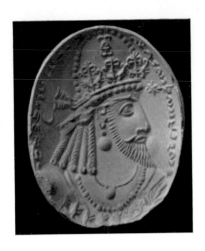

[50]

A Sassanian Gem

This finely-cut seal-stone is inscribed round the edge in Pahlavi, '*Vehdin-Shapur, chief store-keeper of Iran.*' The royal figure on the seal may represent Yazdigird I (A.D. 399–420) whom, according to literary sources, this important official served.

Sassanian. Early 5th century A.D.
Carnelian. 4·6 cm high × 3·7 cm wide.
A. D. H. Bivar, *Catalogue of the Western Asiatic Seals in the British Museum, Stamp Seals,* II, London, 1969, p. 49, A.D.1.

[Room of Writing 119994]